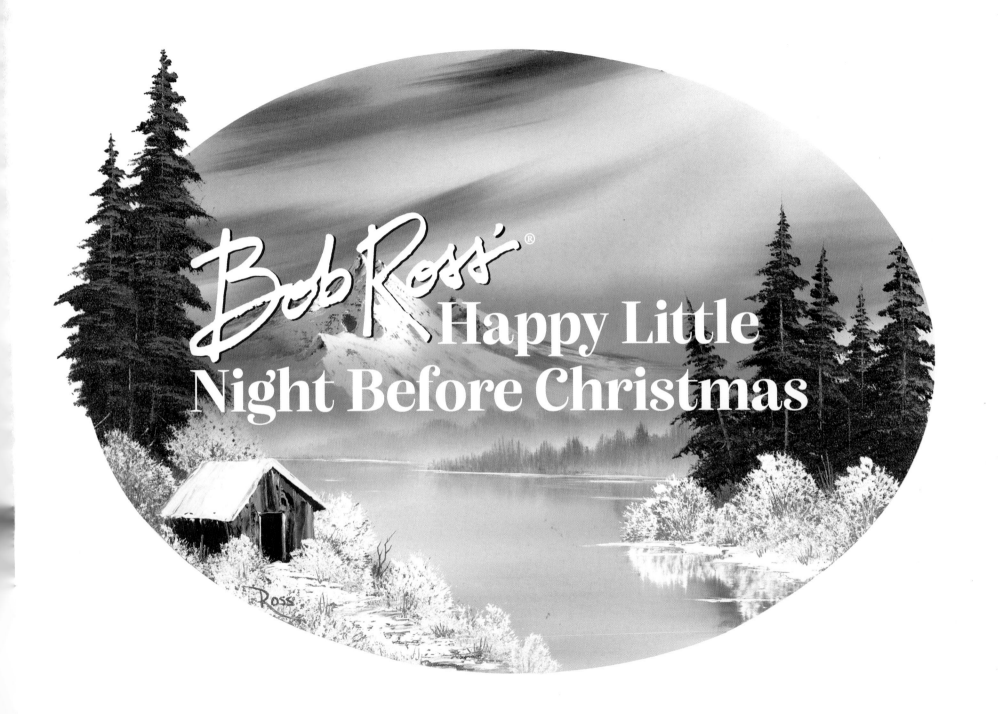

# Bob Ross'
# Happy Little
# Night Before Christmas

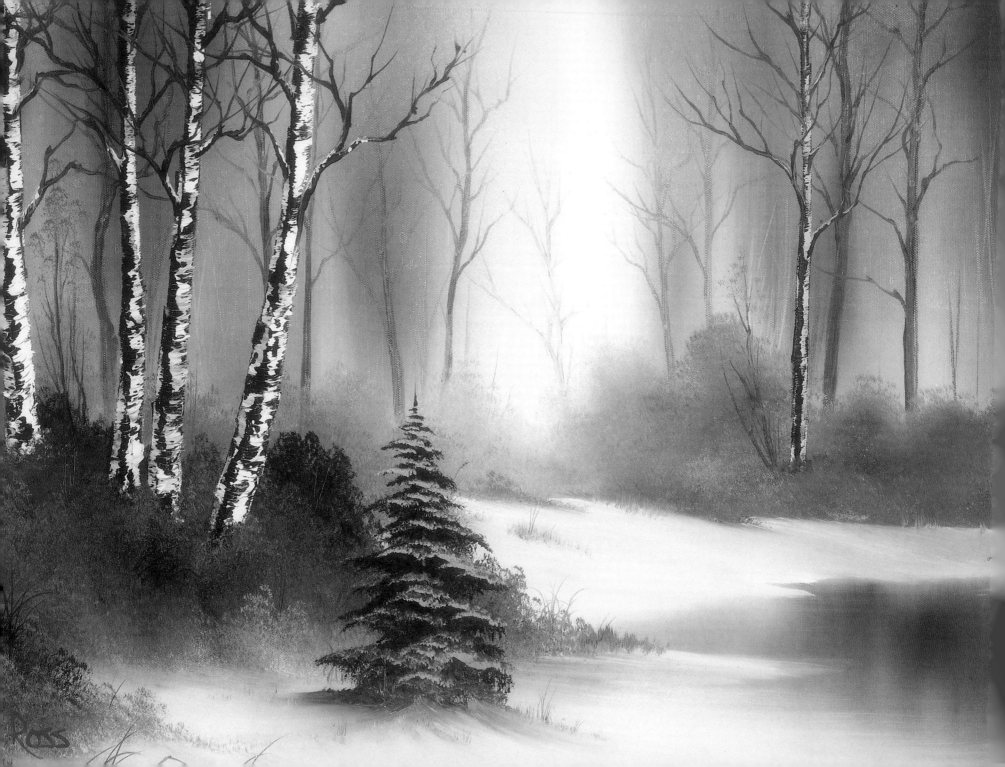

# Bob Ross® Happy Little Night Before Christmas

## Art by Bob Ross • Written by Robb Pearlman

Smart Pop Books

An imprint of BenBella Books, Inc.

Dallas, Texas

'Twas the night before Christmas when all through the trees, the moonlight shone down on frost-covered leaves.

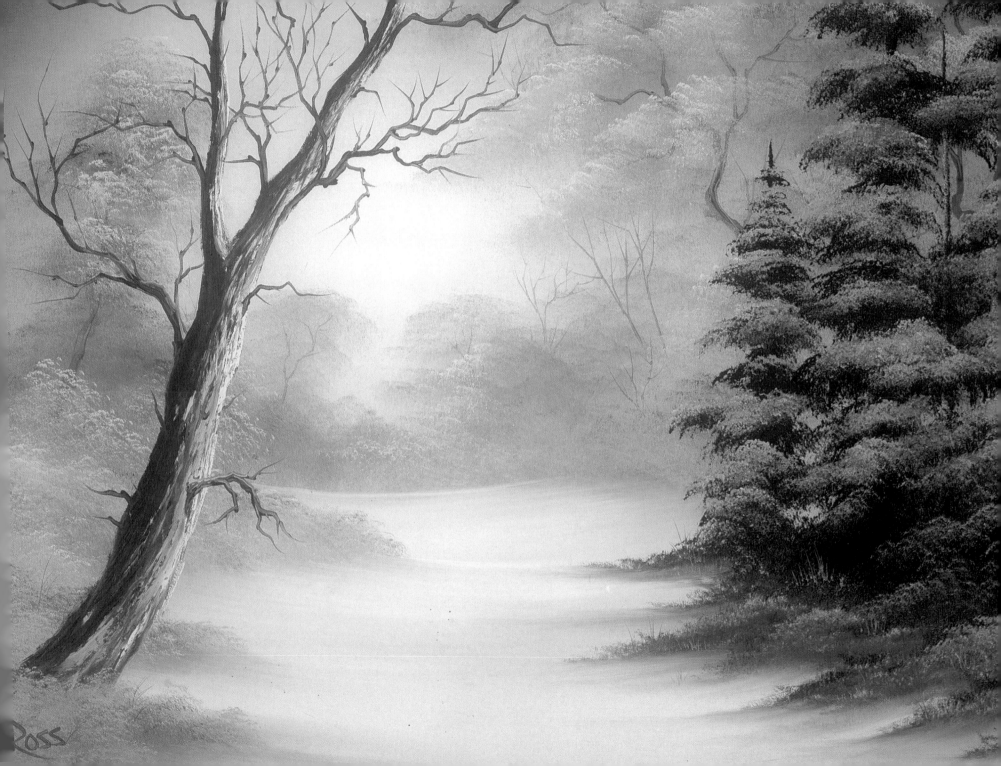

Peapod the Squirrel had left his cold
nest
To nap in Bob's pocket, safe and warm
near his chest.

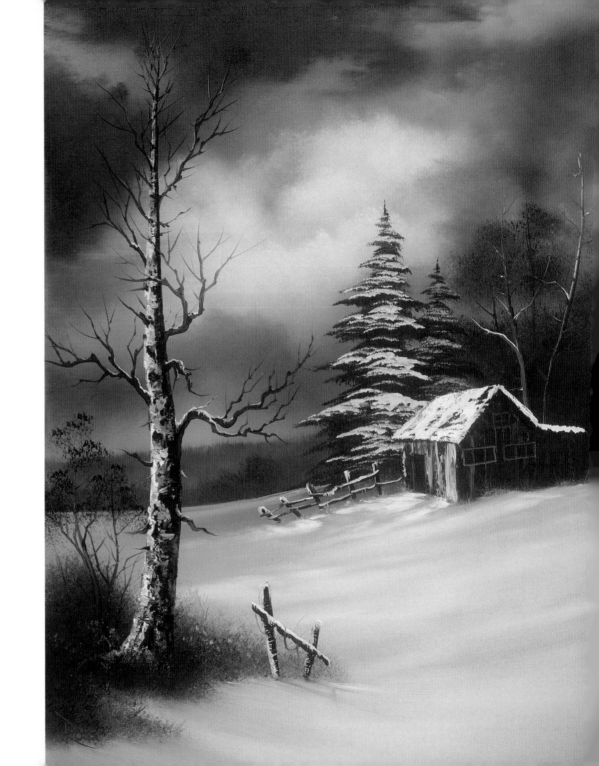

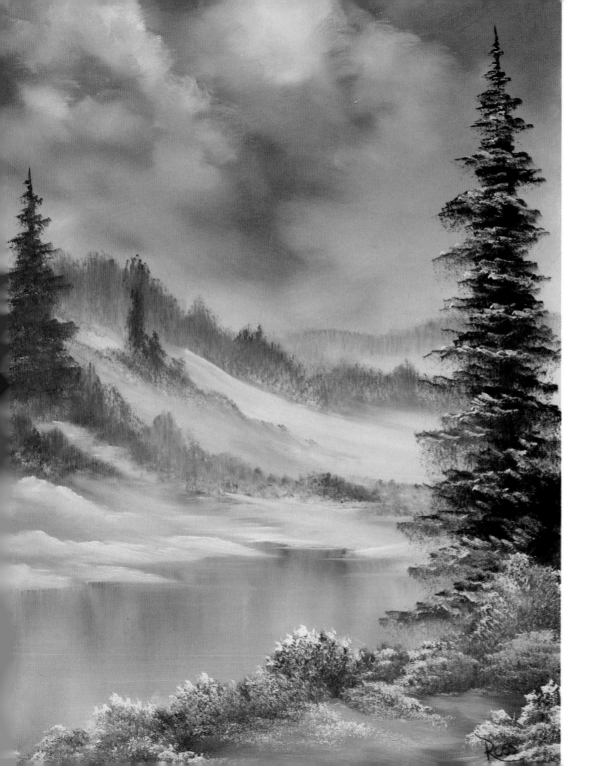

Bob tucked Peapod in as he looked
   out to see
a glow gleaming off every rock, bush,
   and tree.
The bright white snow glistened, the
   brilliant ice shone,
as the cold winter wind went from
   whisper to moan.

He looked at the mountaintops, covered with snow,
and saw the ice forming on streams far below.
Happy clouds floated by in the sky oh-so-clear.
The spirit of the season drew even more near.

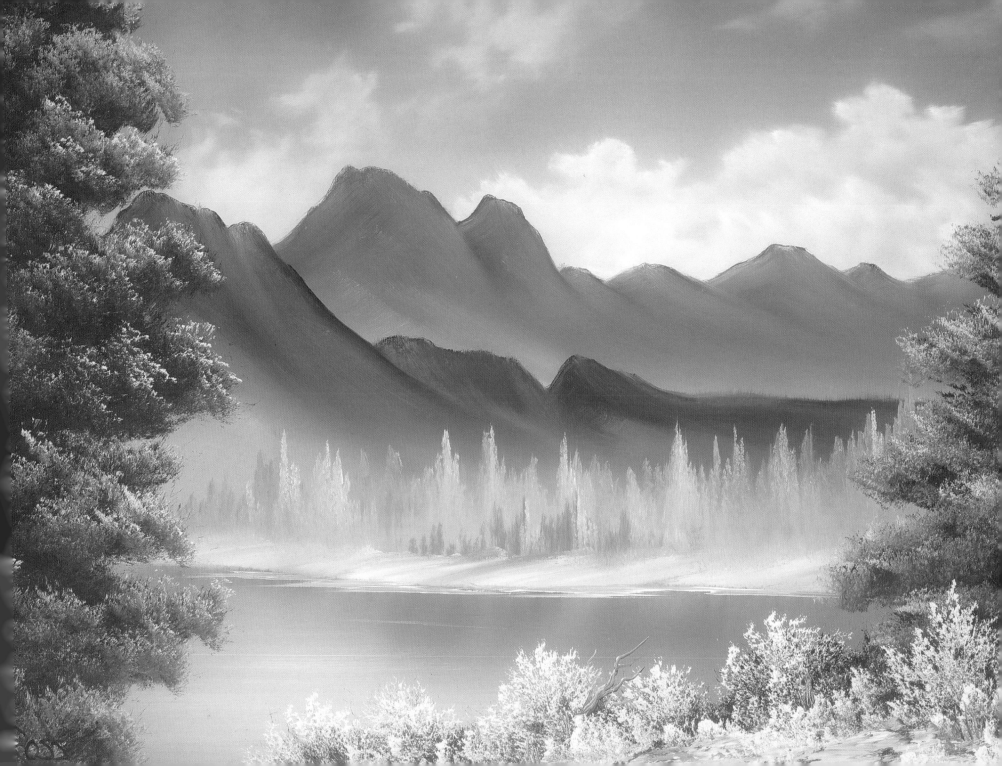

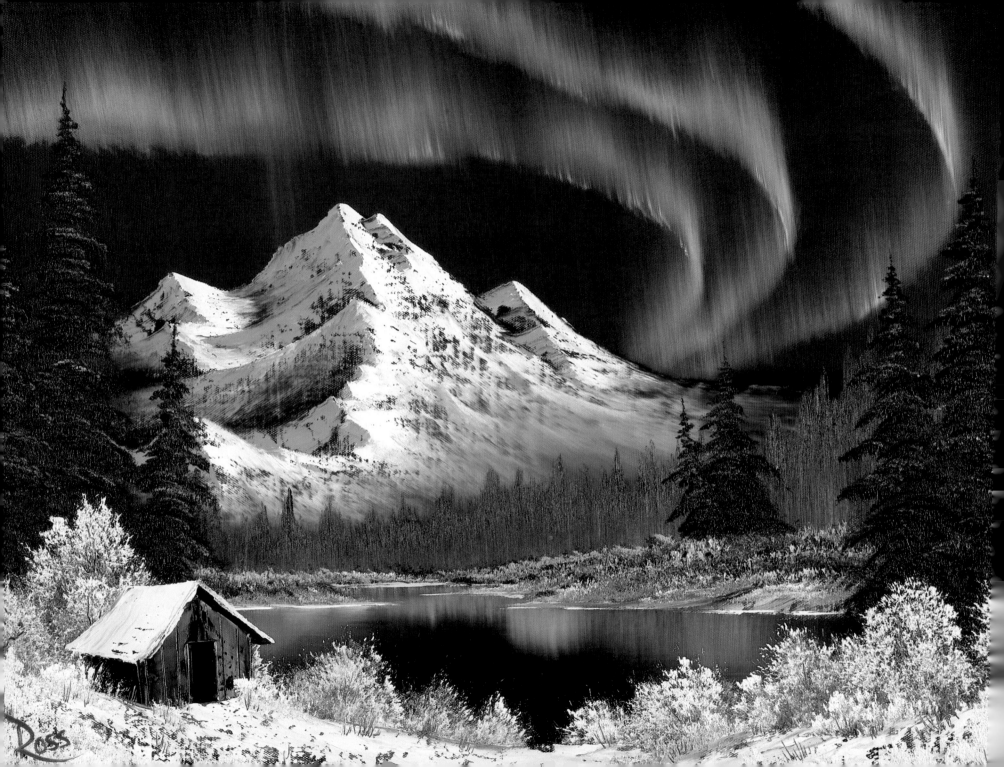

As visions of peanuts danced in Peapod's head,

Bob readied for painting, instead of for bed.

Now fully inspired, Bob wanted to paint

wet-on-wet style, and without constraint.

But what colors to use? Which ones would be right?

Bob used his favorite thirteen hues that night.

He took out his palette and carefully put
on Midnight Black (the color of soot),
on Cadmium, Indian, Ochre (all yellow),
on greens Sap and Phthalo, Dark Sienna (so mellow!),
on Bright Red, and Titanium White,
on Alizarin Crimson (a deep red, not bright),
on Van Dyke Brown and blues Phthalo and
　　Prussian—
those were the colors that he'd dip his brush in.

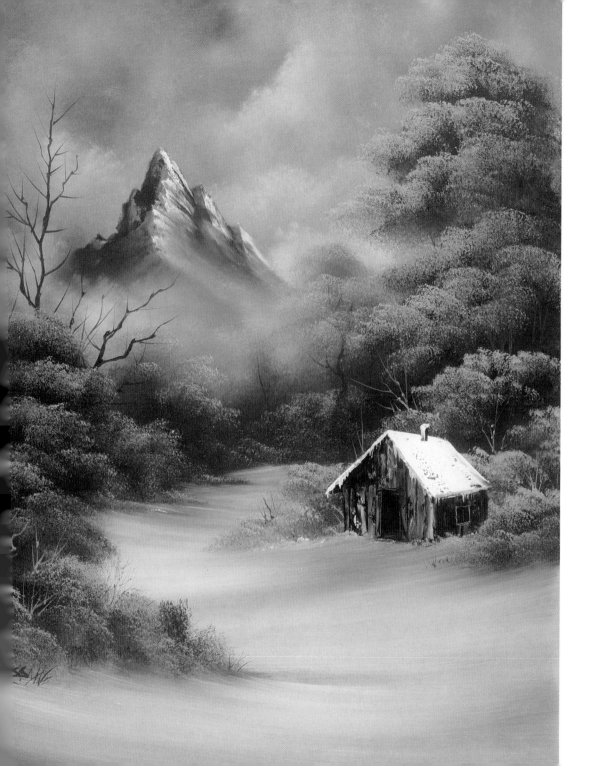

Be they mixed or alone, they're the
colors he'd need
to paint a fresh landscape so calm
and serene.

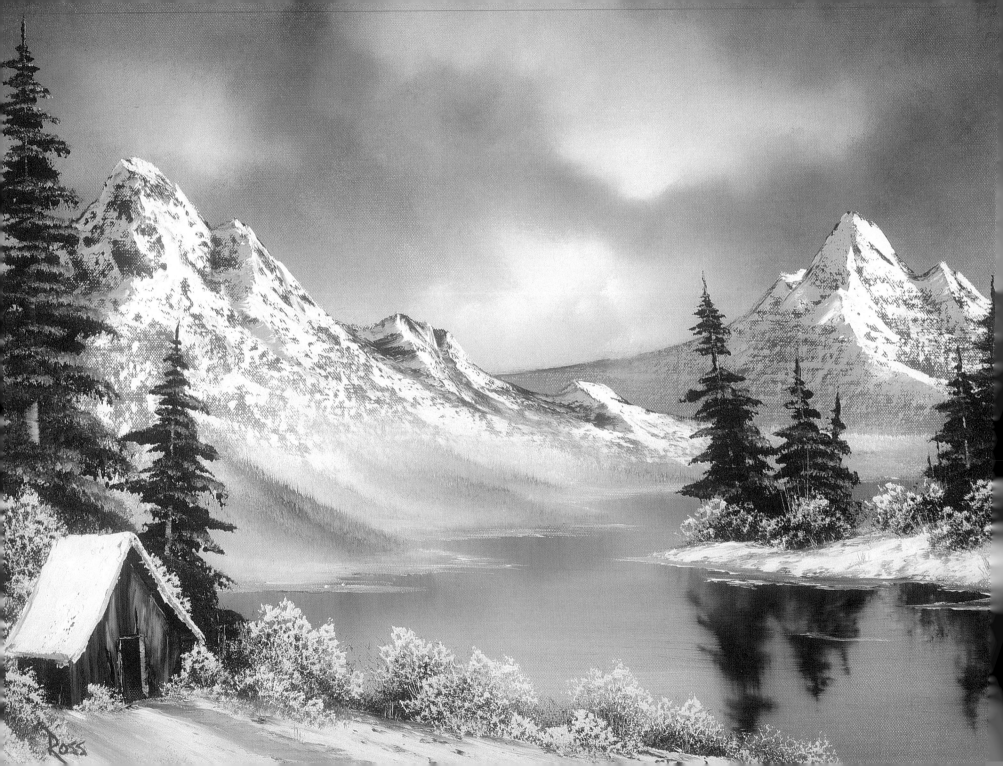

He set canvas on easel, and pulled out his brushes
(some just for broad strokes, some for final touches),
a straight painter's knife, and the bucket they're cleaned in.
The most important tool, though, was Bob's imagination.

He tapped some paint here. And some over there.

Make a mistake? Don't know? Don't care!

They're all happy accidents, no need to worry.

A stray brown dot's covered by a nice white-blue flurry.

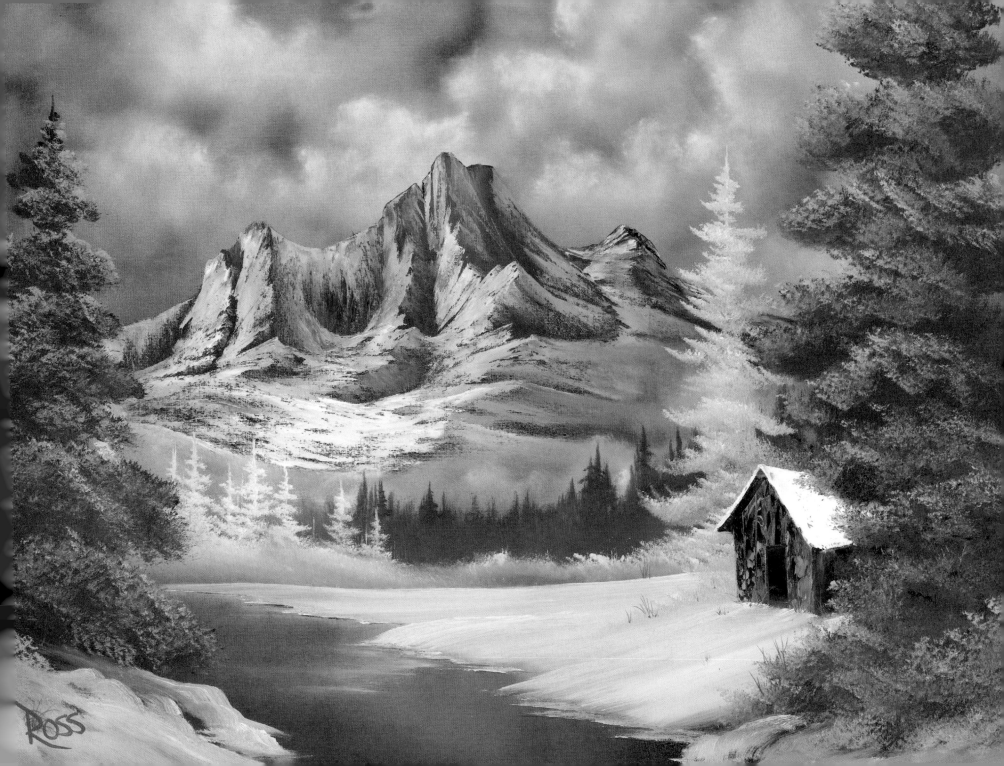

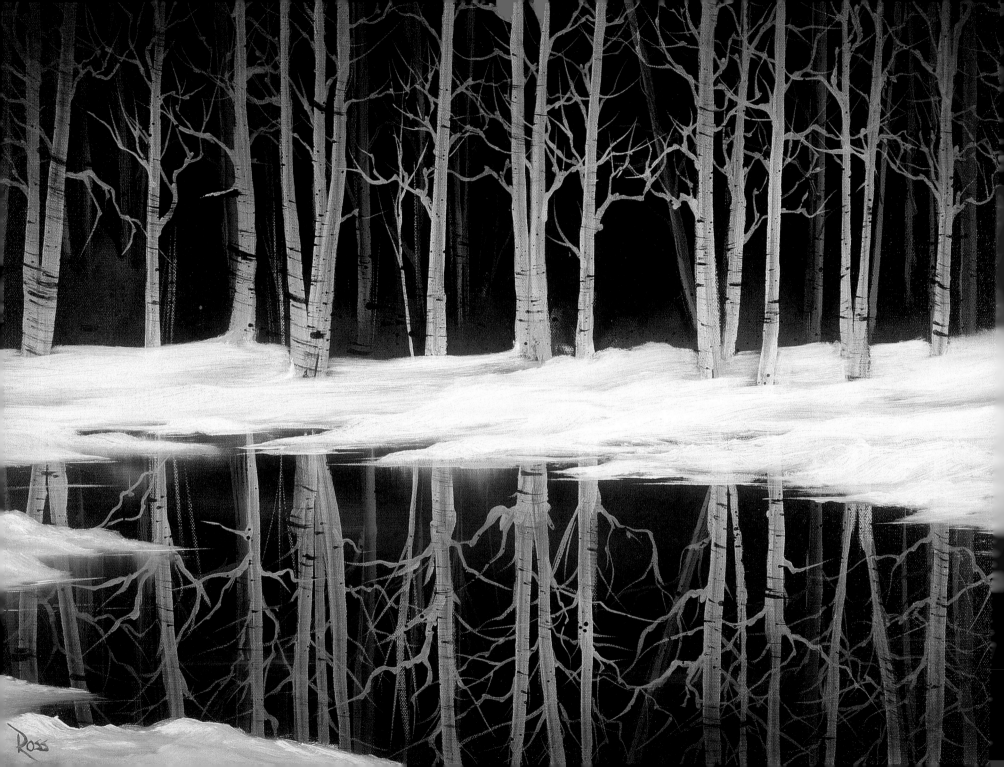

Every tree deserves a friend.

And look, that one's tired, so give it a bend.

Add some shadows: they show the light.

And don't forget snow — use a touch that's quite slight.

As Bob painted the landscape, all wintry and quick,

he thought of his family, and he thought of the sick.

He thought of world peace, and he thought of a dove.

He thought of his friends and he wished them all love.

He thought of Santa, the elves, and reindeer.

He thought of the promise of a prosperous new year.

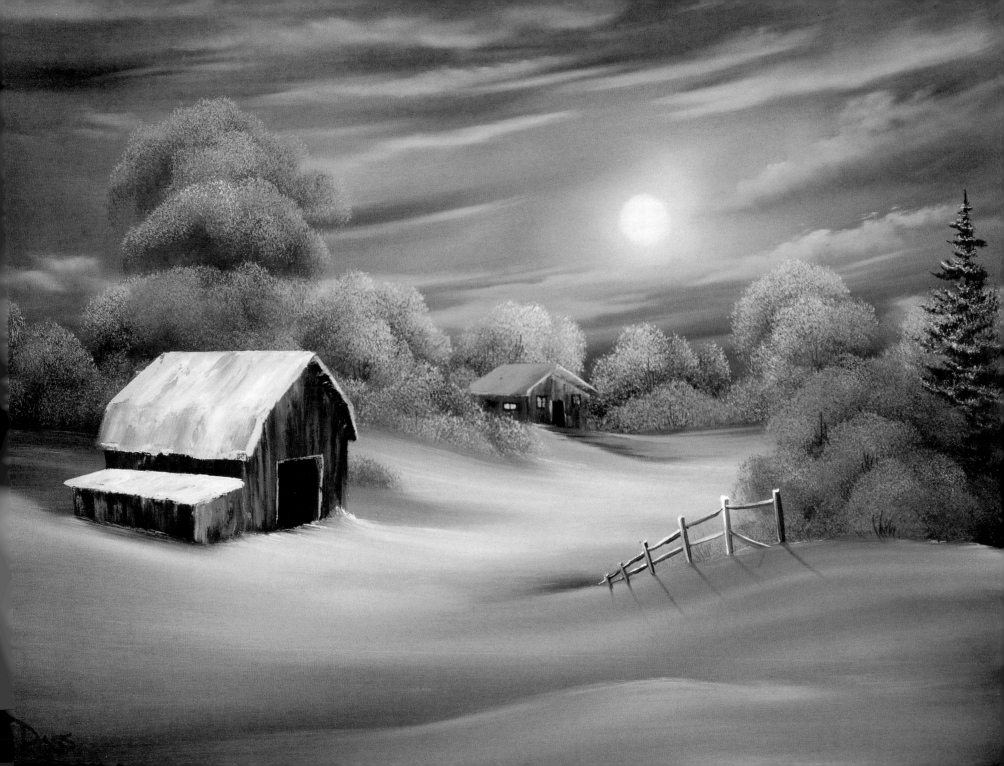

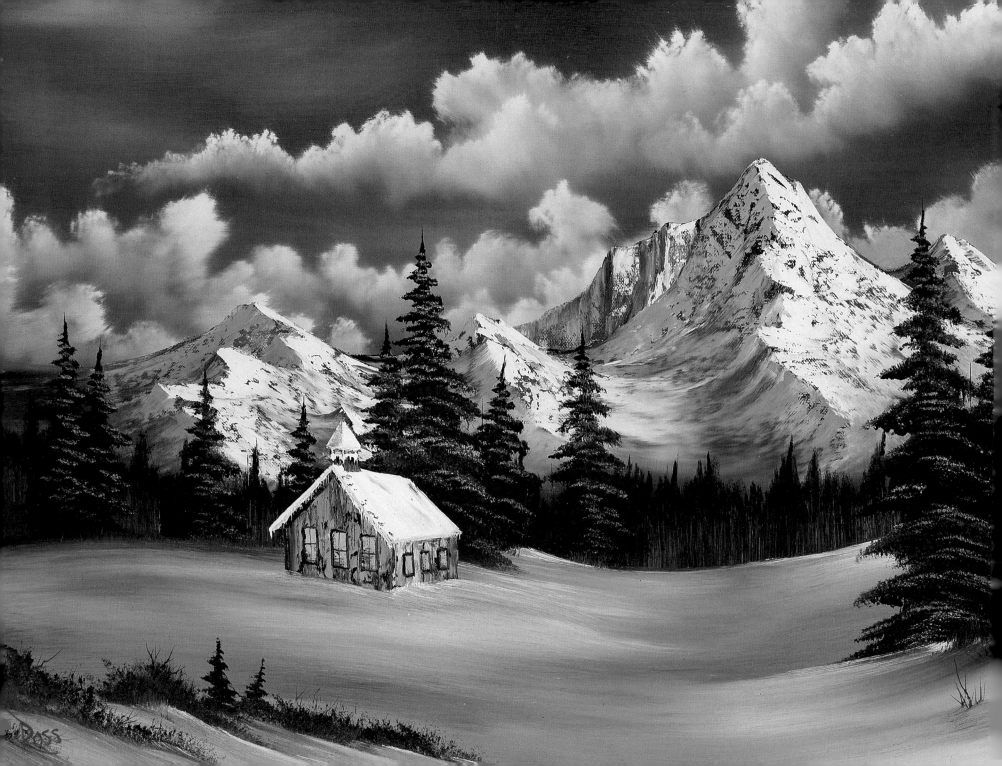

He prayed for us all—for me, and for you.
He prayed we'd be kind, whatever we do.

As Bob signed his name, the clock struck midnight.
It was now Christmas Day, and with all of his might
he vowed to hold on to what he knew was true:
that the gifts we are given, by nature—by life—
are best passed to others. Bob knew that. Do you?

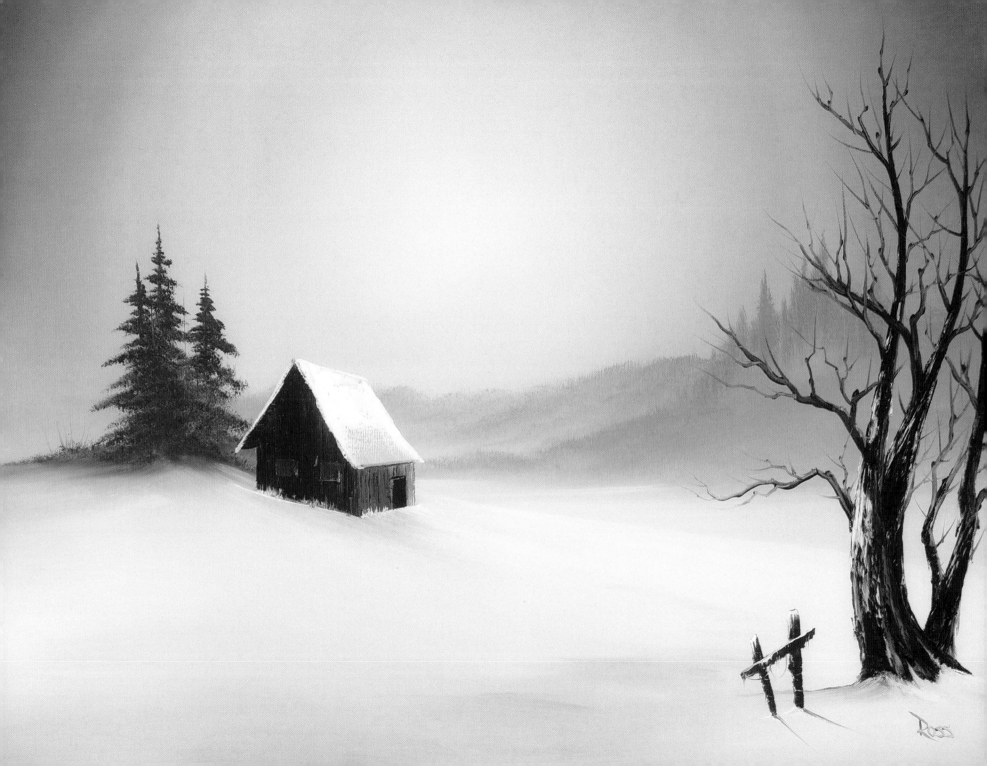

For being an artist is not just a job.

It's something you are. It's someone like Bob.

And though painters are special any time of the year,

they're even more special right now. Right here.

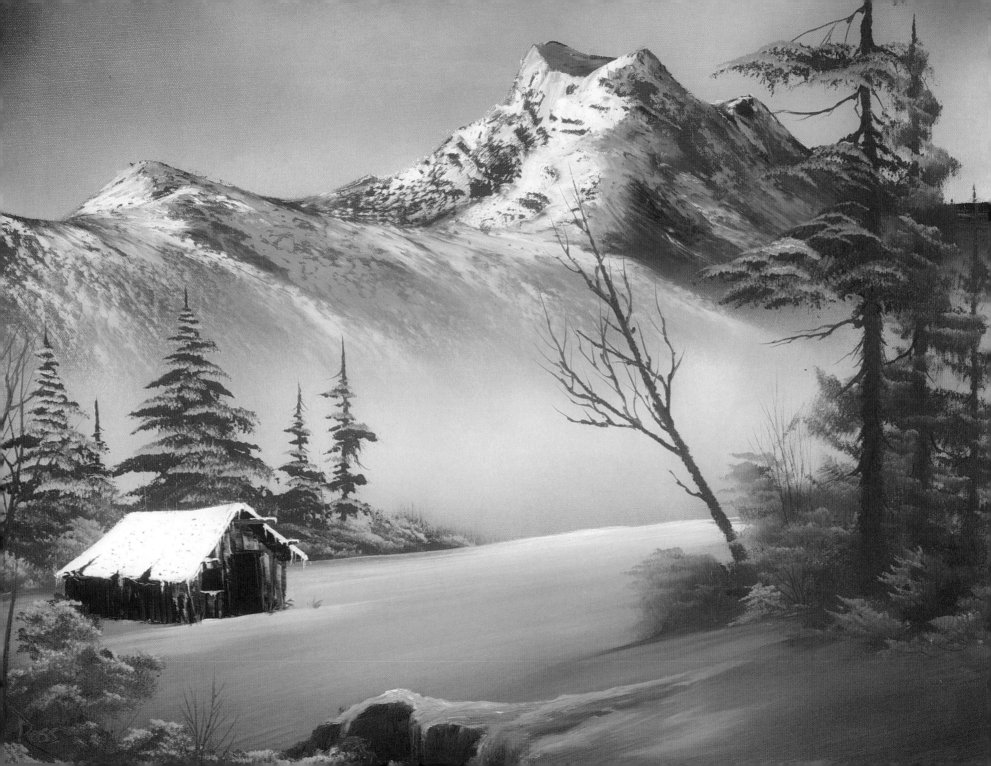

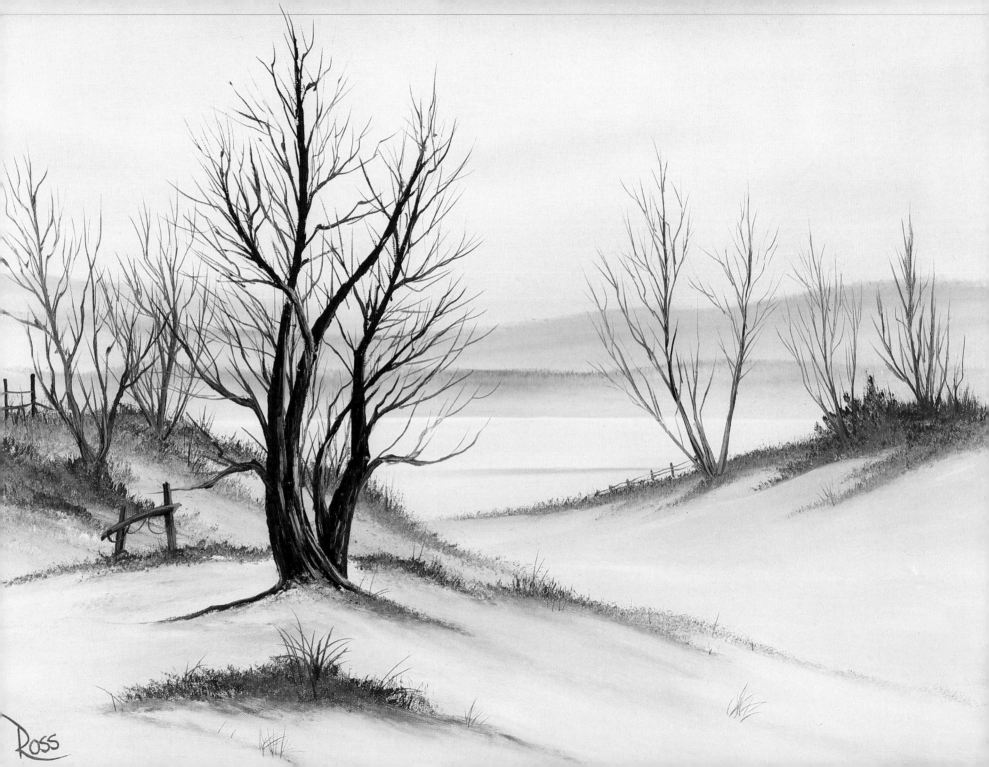

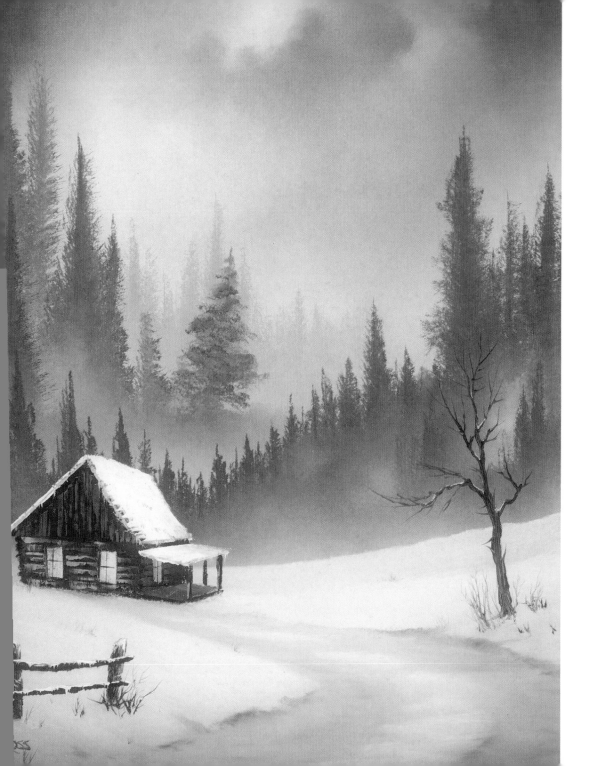

If you don't believe me, try a painting
   yourself.
Then hang it on a wall, or set it on a
   shelf
and you'll know—you'll see—that
   you've the gift, too.
Bob knew you can do it. And now you
   know, too.

So for this season, and for each season hence,

I wish you happy painting, my friends. And a heartfelt *God bless*.

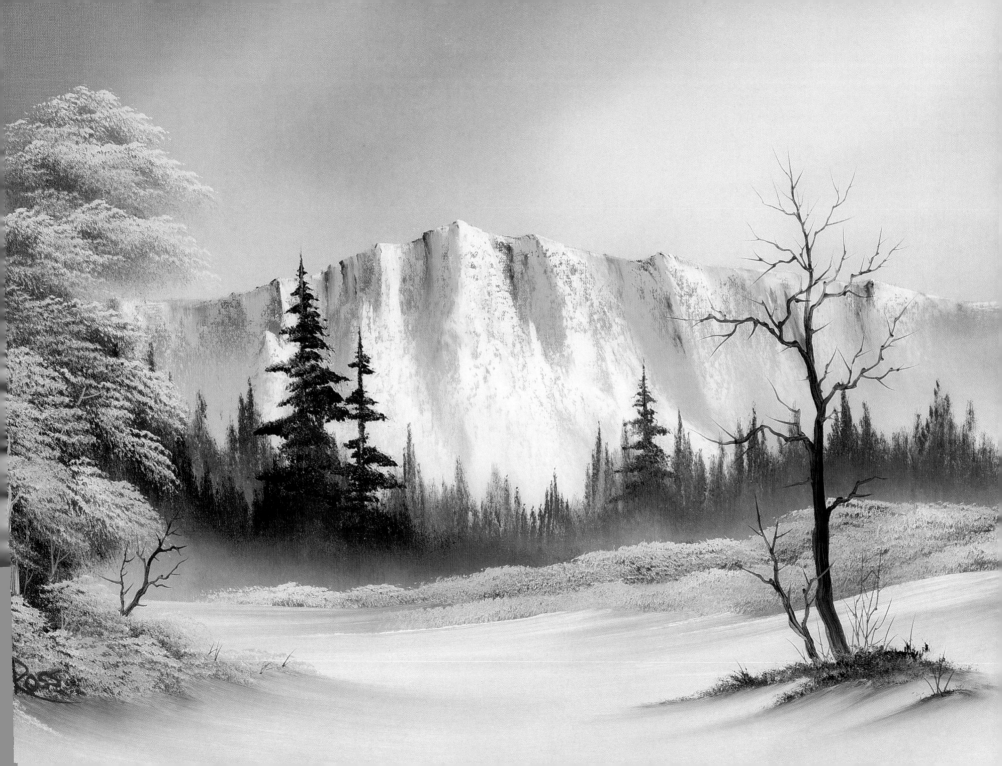

Smart Pop is an imprint of BenBella Books, Inc.
10440 N. Central Expressway
Suite 800
Dallas, TX 75231
smartpopbooks.com
benbellabooks.com
feedback@benbellabooks.com

*Smart Pop* and *BenBella* are federally registered trademarks.

Printed in the United States of America
10 9 8 7 6 5 4 3 2 1

Library of Congress Control Number: 2021012518
ISBN 9781637740187 (paper over board)
ISBN 9781637740248 (ebook)

Editing by Leah Wilson and Rachel Phares
Copyediting by James Fraleigh
Text design and composition by Aaron Edmiston
Cover design by Brigid Pearson
Cover image © Shutterstock / ViDI Studio (santa suit); painting, Bob Ross head, and signature are registered trademarks of Bob Ross Inc. Used with permission.
Printed by Lake Book Manufacturing

Special discounts for bulk sales are available.
Please contact bulkorders@benbellabooks.com

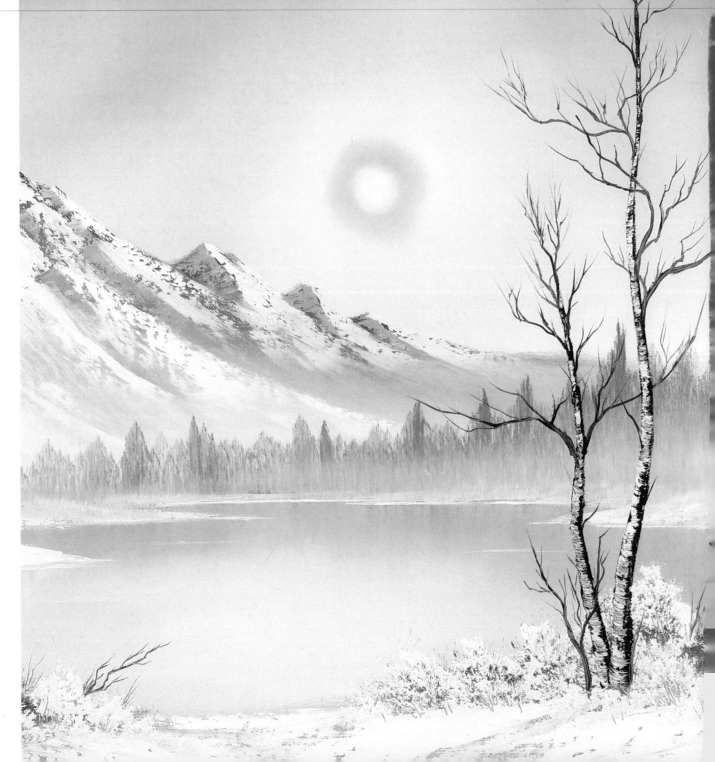